DRAKE MASTERS

Except where obvious, this book is a truthful recollection of actual events, places, and conversations in the author's life.

Like That. Copyright © 2020 by Drake Masters.

ISBN: 978-0-578-73382-1

Library of Congress Control Number: 2020914987

Cover design by Darya Shnykina

First paperback edition: September 2020

www.drakemasters.com

For anyone that has ever approached me in real life
to tell me how much they liked a status I wrote online.

They don't think it be like it is, but it do.

– Oscar Gamble

PREFACE

Like many things that I do, I created *Like That* to see if I could. One night, well past my bedtime, I had a thought: what if made a book? And what if that jawn was deadass a compilation of 100 of my favorite and most defining Facebook statuses?

From a silly idea came a serious goal. If I was going to make this book, I wanted to do so correctly and professionally. To that end, I set about learning book design and layout, proofreading and editing a manuscript, publishing and marketing, distribution options, and a slew of others things I've since forgotten. The creation of this book was no simple drag and drop affair. I've done my best to recreate the design of Facebook's user interface, in book form: matching font, style, and look; all with the intent of giving *Like That* the appropriate feel. And as a book of Facebook statuses wouldn't be complete without them: I've also incorporated status reactions, in analog form. Please feel free to pencil in your reactions.

All that said, what you're currently holding isn't a slapdash effort to generate a profit from something that you've always gotten for free. I've used social media as a journaling tool for many years. *Like That* is a curation of those thoughts, and in some ways a memoir. It catalogs my experiences, and subsequent responses to them, throughout various periods in my life. *Like That* is a small part of me; one that I ask that you be gentle with, as I couldn't afford the production costs of a hardcover version.

 Drake Masters
March 22, 2020 · 👥

Listen, I don't care whether or not you still love me. Baby, do you still think I'm funny?

Drake Masters
July 3, 2018 ·

It's 2018, I don't believe that we should still celebrate men for purchasing tampons for their partners, but if anyone wants to see me on television tonight, I'll be accepting the key to the city for my efforts.

Drake Masters
January 19, 2019 ·

I'm pleased to announce that I've won the Academy Award for Best Actor. The award comes as a result of my ongoing performance as someone who understands sports.

I'm grateful for the award, as well as the accolades and recognition that comes with it. However, I want to note that these things were never my intention. I simply wanted to act. In fact, I've been in character for so long that it's become a part of me. With each sport's play that I pretended to understand, and with each player's name that I mumbled, until someone guessed what I was trying to say (and I agreed), I felt more connected to the games; connected in a way that, with enough time, allowed me to reduce my interactions to head nods, exasperated gasps, and the occasional "we'll-get-em-next-year." This performance wouldn't have been possible without the support from fans who bolstered my growth by assuming my blank stare meant that I knew what the hell they were talking about. This one is for them.

In closing, go local team!

Drake Masters
August 19, 2020 · 👥

No one can make my toes curl like my dentist can. Our safe word is "Isn'tThatALotOfBlood?"

Drake Masters
May 12, 2018 ·

The hairline of the Caucasian male is the epitome of white privilege. Their hairlines do whatever, and go wherever, they want and there's nothing anyone can do or say to stop them.

Drake Masters

August 23, 2012 · 👥

I'm old enough to remember when you could get a gallon of gas for a dollar. However, that's not my fondest childhood memory of what a dollar used to buy you. Hands down, the best thing a dollar bought was a hoagie: the fabled dollar hoagie. You could buy one anywhere. All you had to do was borrow (steal) some money from your parents and walk (run) to the nearest corner store. With that dollar you'd receive a reasonably sized hoagie, with the works (sweets and hots, if you were lucky). And for an extra fifty cents some stores would bundle in a bag of chips and a canned soda. That marketing was so good it made the ass-whooping you'd get for stealing your parent's money worth it.

Drake Masters
September 3, 2013 · 👥

Of all the people in the world who can't sing, I sing the best.

Drake Masters
February 19, 2016 · 👥

Earlier this semester, for my public speaking course, I did a presentation on how to kill a person. It was titled "How to Kill: Pew Pew Everybody Gon Die" and covered, as you may have guessed: how to kill someone, the difference between murder and justifiable homicide, and various scenarios to help differentiate between the two. My professor no longer requests that we "surprise him" with our presentations, and now requires that they all be submitted to him for approval, before students are allowed to present them.

Drake Masters
May 7, 2018 · 👥

Shout-out to my mother for giving me the gift of perfect posture. When you're the child of a single parent, it's guaranteed that you're going to get your ass beat for two. You get your whopping *plus* an additional beating that's really meant for your parent's absent partner. Most single parents bundle both ass-whoppings as a package deal, but occasionally you'll get an unsolicited one for free, just for resembling the parent that quit the relationship.

Drake Masters
June 15, 2016 · 👥

I want the kind of confidence that Mormons walking through the hood have.

Drake Masters
July 16, 2014 · 👥

The irony in success is gaining followers while losing friends.

Drake Masters
June 28, 2013 ·

The funny thing about equality is that it's equitable on all levels. Surprising, I know.

All too often I hear members of the various disenfranchised groups tearing down one another in their pursuits of equality. For example, people of color have no problem seeking equilibrium from the world while omitting that same right for the women of their group. Following in that same vein are members of the gay community that treat the notion of parity for people of color as a struggle that has run its course, failed, and is no longer worth mentioning.

The fight for equality isn't a contest in which we measure oppression. It doesn't matter which group has been wronged for longer or which group suffers the most. All that matters is that each obtains equality, as is deserved by all humans.

 Drake Masters
August 24, 2020 ·

Some people are bottom-tier racists. Their racism isn't based in feelings of superiority, they're just still upset about something that happened in their past. Feeble feelings. Like how you hate me, because some black kid tripped you in front of your crush, way back in 97? I'll trip you now.

Drake Masters
November 30, 2018 ·

Fast-food salad is the "I miss you" text sent to your ex during a moment of 3am desperation. You know it's no good for you, but it has to be better than the other options, right?

Drake Masters
October 3, 2012 ·

I find fault in the statement, "You can't put a price on a human life." Quite to the contrary, if you've ever been in the military, law enforcement, or any other profession of public service, you know that the price of a human life is most often a hourly wage.

Drake Masters

July 20, 2014 ·

Civilians: Hello Airman, I can see that you're in the Army so I'm going to ask you a bunch of questions about being in the Navy, but first: what's it like being a Marine?

Drake Masters
July 14, 2020 ·

If we taxed white people every time they used the word nigga, we'd have more than enough money for reparations.

Drake Masters
August 26, 2016 ·

I'm working more than 40 hours a week and still can't afford my company's healthcare. That's pretty salty, but not too salty, I can't afford to have high-blood pressure.

Drake Masters
April 15, 2019 · 👥

I wonder if any cops that want to go undercover ever get rejected because their plain clothes outfits are whack.

Imagine being an officer on the verge of bringing down a large criminal organization, but you can't move forward with the deal because the dealers are roasting your fake ass Jordans instead of selling you drugs. They're dying (not in the way you expected) and you're stuck there just sweating because you don't have many outfits that aren't your uniform. *Deep breaths.* You're trying to stay calm, but through your wire you can hear your squad in the parked van outside. Of course, they've been listening in on the deal. You can hear them cackling. *How unprofessional.* A pause, and then your captain's on the line, speaking through your earpiece. Your captain's a good man. You know he'll abort this mission or send the full team in now. Instead, through stifled chuckles, he asks where the hell you bought a Karl Kani shirt from in 2019. Your blood begins to boil. You've had enough. You're going to finish this.

You reach for the briefcase containing the drugs, but as you do so, the dealers reach for their guns. Now stoic, they utter only two words: "We know." *Fuck*. Sweat begins to dot your forehead. Your cover is blown. You're facing death, yet still, all you can think about is how you should have worn a Champion jersey. You close your eyes, and at that moment you hear two loud clicks. Their guns are cocked. You're frozen there awaiting your fate. Moments that feel like months pass. You're not dead? Cautiously you open your eyes. The dealers have closed the briefcase and they're packing up to leave. You shoot them a puzzled look. In response, they laugh and say "We know ... that a motherfucker wearing Girbaud jeans can't afford this much dope."And just like that you've failed your first undercover mission. The dealers leave quickly. A sigh of relief escapes your mouth as you remove your Allen Iverson headband.

The next day, you're in your captain's office turning in your gun and badge. As you walk towards the door, he asks you where you'll go from here. From over your shoulder comes your final response: City Blue.

Drake Masters
November 30, 2016 ·

If white people spent half as much time using their influence to fix societal issues as they do appropriating elements of Black culture, the world would be a better place.

I mean, I get it, my nigga, you can nae-nae, but would you mind correcting institutional racism a bit?

Drake Masters
December 17, 2011 ·

The best thing about my Psychology course was that I had a classmate who was deaf. Now, hold on, before you go calling me a jerk. The reason that I enjoyed this was because when I would tell a joke in class, her translators would tell her what I said using sign language. After a slight delay, she'd share in the laugh and then look over at me and smile.

It's one thing to be funny in the English language, but I've never felt as rewarded as when, after nervously watching the translation, I'd receive her approval.

Drake Masters
April 5, 2016 · 👥

Chance's verse on Ultralight Beam hits me hard. Last year, "a nigga was lost." I'd been wrongfully terminated from my job, my relationship with the woman I'd planned to marry ended, and I was forced to give my pets away as I was in danger of losing my home. As a result of all this, and being shackled back into the debt that I'd recently spent years purging myself of, I was extremely depressed. For a time, the simplest and most rational solution to my problems seemed to be to just kill myself. Thankfully, I did not. And for good reason, I've picked myself up this year. I've worked hard on pursuing my aspirations and what makes me happy. And my efforts have paid off artistically, financially, and emotionally. I've obtained more success and advancement in the first 4 months of this year than I have in the last 4 years I've been practicing photography. More importantly, I'm happy and each day I work on being even more so. Shit, man these days "I'm just having fun with it."

 Drake Masters
December 28, 2018 ·

I went from being so poor that I had to steal clothes from
Forman Mills to shooting designer clothes for fashion editorials
in Vogue. Your past doesn't define your future. Keep hustling.

Drake Masters
November 22, 2012 · 👥

I enjoy the subtlety that 'liking' someone's comment on Facebook can offer. A 'like' can say either "I agree with your statement" or "Please shut-up, I'm tired of talking to you and would rather you go fuck yourself."

Drake Masters
July 18, 2016 ·

What I don't understand is how euthanasia (mercy killing) is legal in the Netherlands, Belgium, Ireland, and Columbia, but here in Philadelphia, it's frowned upon when I ask the person already killing me with small talk to just finish the job. Can't you see I'm suffering? Just end it already!

 Drake Masters
July 17, 2016 · 👥

The goal is to take so many self-portraits, that if a cop kills me, the media can't help but promote my work.

Drake Masters
May 7, 2018 ·

A cop pulls up next to me at a traffic light. He hits his siren to get my attention. I start reaching for my racing gloves, but stop as he asks if I know that one of my headlights is out (it's the passenger side light, I sacrificed it to avoid a larger crash last Noreaster). I figure he's asking because he's testing me. He wants to know if I'm blind. I'd have to be to miss the fact that my car is currently in its hoe phase: it winks at every car we pass at night. I tell him I'm aware that it's out. He asks, "How long?" I reply, "Not long (a lie). I was just hit by a spiky, blue, turtle shell. Caught slipping." He laughs. I leave. Thankfully, neither one of us make headlines.

Drake Masters
December 21, 2018 · 👥

One of the perks of moving out of the hood is that I can snitch freely now. So, if you think you're going to make a narcotics exchange in front of these brown eyes without consequence, you've got another thing coming. Not in my suburbs! You're going to jail, Tyler!

Drake Masters

January 4, 2020 · 👥

Everybody wants to date an artist, but nobody wants to "Yeah, right there. No, move your leg back. Wait. Listen, the light … stop. Hold it." So that I can make the damn picture.

Drake Masters
July 6, 2016 · 👥

To be Black is to be both fearful and feared.

Drake Masters
October 15, 2017 ·

I never know which grapes to buy at Whole Foods because white people are always eating them out of the bag and then walking away without buying them. And before you fix your lips to say, "not all white people," let me smell your fucking breath.

Drake Masters
July 13, 2020 · 👥

I like to start each morning with a moment of reflection, as I put on my mask and smell yesterday's breath.

Drake Masters

December 20, 2018 · 👥

The year is 2048, we finally have the technology to relive past memories. Your grandchildren have stumbled upon a hidden cache of your most embarrassing memories and are experiencing them through the use of virtual-reality headsets. One memory in particular shows you losing a fight back in 2019. Technology is so advanced that they're actually witnessing the moment as if they were in the crowd all those years ago. The quality of the headset's rendered imagery is so crisp that they now know the facial scars you have (the ones you claimed you got serving in Trump's WWIII) actually came from falling on a broken corona bottle during this fight. They no longer respect you. In school they don't make you macaroni art that spells your name. Instead they bring you macaroni shaped into the form of a large letter L. Those turkeys that kids make by tracing their hands. Well, they only use two fingers when making yours; you receive further Ls. You're indignant. Your parents would have beaten you for this. You've thought about it, but they've watched the video of you getting trounced so many times that they know all of your moves. You know you'd probably get trashed again; your cache of ass-whoppings growing ever-larger.

People, please make 2019 the year that you release your anger in more productive ways. Because you can't afford to get beat up these days when everything becomes a video on the Internet. If you won't do it for yourself, do it for your children's children.

Drake Masters
October 23, 2016 · 👥

I wasn't aware of my success until they started building a Wawa in my neighborhood.

Drake Masters
June 25, 2019 ·

I'm the only Black art director at my agency, on my floor, and possibly, in my company. It would be naive of me to consider this an achievement. My circumstances growing up were the same as most Black males in the inner-city. At an early age I became aware of the many pitfalls present in the trap. My "success" in avoiding (some of) them makes me an exception to the statistics, not the rule. Therein lies the problem.

Black children cannot afford to make mistakes or have missteps. They are not allotted do-overs. Being born poor and Black is in many ways a death-sentence, not simply of body, but of experience and opportunity. For that reason, I can not revel in any success I may feel. Instead, I feel revulsion towards a society that pushes adages about bootstraps, but equips only a select few with boots.

 Drake Masters
August 24, 2016 · 👥

I've been getting my head nods mixed up recently. I've always given the head-nod-of-solidarity to my Black brothers when passing by them, but now I also have another head nod to keep track of: the bald-men-nod. The issue is that they're almost identical; the most notable (and dangerous) difference is that one of the head-nods is backed by the power of 400 years of surviving oppression. I can't tell you which one though, that's against the code.

Today, I fucked up. At work, I mistakenly gave the head-nod-of-solidarity (which is only intended for Black men) to a bald, white guy that works in IT. Disastrous, I know. Now this dude, Dave, I think. Well now, fucking Dave has become so emboldened that he's been using the company-wide email system to send out his mixtape.

Drake Masters
March 12, 2019 · 👥

I feel like every fashion photographer in New York has a story about how they moved there with nothing but a Calvin Klein bra, a pair of ripped jeans, and a high-contrast black & white filter in their pockets.

Drake Masters
August 30, 2016 ·

It's amazing to me the media that men will share in the name of "entertainment." Media that directly contradicts any interest in the well-being or protection of women. It goes something like this on social networks: "Hey, you want to see this video of two girls fighting over a boy? How about this clip of a women getting beaten by her boyfriend? No? What about this 'funny' meme with strong rape overtones?"

As men, we have to do better. Sure, you might not be a rapist. You may not be misogynistic (I'd argue with you there), but when you seek out, view, and share material that casts women in a dispensable, sexualized, or objectified manner, you show your support for it. You effectively say, "I see nothing wrong with this. It's funny."

Listen to me: over time, the material you view gets absorbed into your brain, it influences you, your perception, and your viewpoints with lasting effect. Sure, you might not be a rapist. You may not be misogynistic. But what happens when you're confronted in real life with a man that is? Who's to say that after getting your laughs from videos of women getting beaten by their boyfriends, that when a woman or young girl is within helping distance, being beaten or raped, that you'll come to her aid instead of whipping out your phone and becoming yet another person creating the content that you think is so funny?

Please be and do fucking better. "Man up."

Drake Masters
April 18, 2018 · 👥

To this day the reason for the Iraq war is hotly debated. Contemporary thought asserts that the Iraq war was a response to 9/11, meant to challenge terrorism abroad. If you're woke, you believe the truth is that America sought oil by force. And if you're woke-woke, you know that the real reason that America deployed troops in the Middle East is because the hood was in dangerous need of an influx of Dodge Chargers and Chevy Camaros.

Drake Masters
October 23, 2019 ·

Once I obtain the remaining 4 pieces and summon Exodia, it's over for you bitches.

Drake Masters
June 17, 2019 ·

The cheesiest word an artist can call a subject is "muse." That's so lazy. There are more eloquent ways to say that you wish they were single.

Drake Masters

August 24, 2013 ·

Hood morning. Here's a metaphor that some will be well aware of, and others will vehemently deny: America is a pie; one group disproportionately receives all the slices while the other groups receive prison time for daring to reach for the remaining crumbs.

Drake Masters
November 21, 2019 ·

I hate asking white people "you good?" They never seem to comprehend the context. Instead they respond with some shit like "I stayed up too late last night." No, stupid. That's not what I meant. Fight. Me.

Drake Masters
October 9, 2019 · 👥

I wish photography was more like battle rap in the early 2000s. For example, if you're beefing with another photographer, to make a statement, you'd just have to show up to their studio and do a photoshoot while someone filmed it. The whole time you've got 15-20 models standing directly behind you, mean-mugging into the video camera and gassing you up, and every time you take a great shot, you've got one that grabs you by the back of your collar and acts as your hypeman. She just starts going off, shouting your stats, like how old you are and shit. She goes, "He's only 25! Killing the game! And he's shooting on a crop sensor! With one fucking light! You fake ass photographers not fucking with my, shooter! Fuck is you talkin' bout?"

 Drake Masters
September 26, 2019 · 👥

On second thought: don't even send the nudes unless there's a full team to credit. Photography has ruined me. My expectations are too high. Now, we'll both just end up hurt.

Drake Masters
April 16, 2016 · 👥

You ever hear white people talk about getting arrested? For some, artists especially, their arrest record is a source of pride. They make it sound as if being arrested is nothing, a hobby. They actively pursue it. I don't seek that type of stress. I'll tell you what, there could be a child trapped in a burning building and I'd still have to take a second to evaluate my options before going in to rescue them, because I know that as soon as I emerge from that building: coughing, charred and heroic, I'm getting arrested for breaking and entering, kidnapping, and arson.

Drake Masters
May 18, 2016 · 👥

The dichotomy of my soul: Sometimes I'm wishing for frozen yogurt, other times I'm wishing a nigga would.

Drake Masters
January 4, 2020 · 👥

A woman will come over to your place, have sex with you, and then leave without saying a single word about how clean the grout between your shower tiles is. Do better ladies!

·

○ ○ ○ ○ ○ ○ ○

Drake Masters
September 21, 2018 ·

Copyright infringement charges may be cost-prohibitive for many artists to pursue. I never worry about someone stealing my work though. You infringed? Bet. I'll send you one cease and desist letter. Anything afterwards and you just have to fight me. You handle your own medical bills and we'll call it even.
My metadata just says: © 2018 Knuckle Me

Drake Masters
June 5, 2019 ·

Poverty in urban areas can be ended by simply teaching the poor how to save their money. Forgoing frivolities such as food, shelter, and water would enable them to put more money into investing in the capitalist ventures that they studied in prestigious, public schools. They could even ask the police to help out by watching their children.

Drake Masters
February 19, 2019 · 👥

I hate seeing Teslas. Not because my car is busted, but because they're so futuristic. Every time I see one, I forget that we're not further along as a society. Then, I snap back to a reality where we haven't cured cancer or reduced economic stratification because we've been too busy teaching white people not to do blackface.

Drake Masters
December 15, 2018 ·

Fruity pebbles get soggy as soon as you take the milk out of the refrigerator.

Drake Masters
December 19, 2019 · 👥

I just want to be rich enough to say "money isn't everything," in a cashmere accent.

Drake Masters
January 22, 2016 · 👥

9 out of every 10 people will spend a portion of their lives standing entirely too close to me.

Drake Masters
February 21, 2017 ·

If there was an award for accurately analyzing videos of white people singing along to rap songs to see whether or not they say/mouth the word "nigga," I'd be on stage right now reciting my acceptance speech.

Drake Masters
April 18, 2018 · 👥

Black privilege exists. I called a white dude a nigga during an argument once, and he hasn't been approved for a loan since.

Drake Masters
December 31, 2019 ·

It doesn't matter how far I remove myself from the hood, there's something transformative about a stranger's shoulder touching mine at the wrong velocity and force that takes me right back to being 16 and clearing a block with a stolen revolver, or getting jumped by someone I thought was a friend (while another friend stood by watching), or fighting three dudes when I was just trying to finish my laundry, etcetera, ad infinitum.

The wounds from violence may fade, but the scars are indelible; the PTSD and trauma are real. As I struggle with addressing my own violent proclivities as a result of my background, I notice that everyone wants to be hood. Everyone wants a piece of toughness to call their own and a taste of that gang shit.

Real recognize real, and that gang shit will get you fucked up. There's not one sole influence at blame. So I'll just say be mindful of the media you consume, enjoy the art (in some cases recognize it as peformative) and understand that you can do so without the attachment to the trappings of the trap.

If you got out of the hood, or never had to experience it, don't romanticize it. It's called the trap for a reason. Be well.

 Drake Masters
August 4, 2016 · 👥

"It's not even that hot out," he said after removing all of his clothes and layers of skin.

Drake Masters
February 8, 2017 ·

In this day and age weather reports are useless. If you want to know how warm it is, simply step outside and listen for the sound of young bulls riding dirt bikes up and down Broad Street.

Drake Masters
July 27, 2016 ·

Poor Black boys spend their adolescence being told by media, and taught by the history books, that they are nothing. As expected, they feel worthless. This primes them to answer the military's call of being "all you can be." And with dreams of returning as something more, and having more, they're off to take part in a war of which they have little understanding. In that war they'll excel. This is no surprise. War is hell, poverty is just another ring of it. But what's a bit of bloodshed when you've always fought to live? In my experience, Black men were better suited for combat because they were already shell-shocked. And at that, I'd argue that the War on Drugs triggered PTSD in Black men long before the War on Terror ever could.

Drake Masters
April 4, 2016 · 👥

I made honking noises at some geese today. Not because I'm an adult desperately trying to hold onto his sense of imagination and wonderment in a world that seeks to crush those things, but instead because I'm immature and I wanted those stupid geese to know that I'm a person, and I can speak their language, but they can't speak mine.

Drake Masters

December 8, 2016 · 👥

In the gym trying to get as strong as my mother was when she was beating me for cursing in school.

Drake Masters
February 15, 2020 ·

Lemme tell you how I'm in One Shot Cafe, waiting in line, and a little boy is asking around to figure out whose bags are saving a seat at the front. They're mine. I tell him so when he reaches me. Would you believe that he asks me if I can "move my bags" so that he and his mother can sit downstairs (they don't like sitting upstairs — where there are currently open seats). I inform the young sir that I won't be able to move, especially not during this month, I plan to sit my Black ass down. As I make my way to my seat, his mother (further down in line) tells me that "He was just joking," to which I reply "He wasn't. He just doesn't know how to hustle and that's not very Philly of him."

Drake Masters
June 30, 2020 · 👥

Since we're changing everything, but the issue, can we repeal some of the decisions made by local Chinese stores? Black people love shrimp. The disappointment of opening a platter of General Tso's Shrimp to find a meager three shrimp, in a tub full of rice, is a psychological warfare tactic that has plagued our communities for decades.

Drake Masters
February 8, 2019 · 👥

I'm tired of seeing videos where people that are homeless have their reactions filmed after having money "mistakenly" dropped in front of them. Homelessness is so stigmatized that we're surprised when someone homeless returns the dropped money, rather than keep it, because people believe that being without a home is equal to being without morality.

In a country where 78% of workers are living paycheck-to-paycheck, you'd think we'd be more miserly with our biases. Grow the fuck up. We owe it to our collective selves to reach out a hand to those in need, not film them for profit. That means we need to do more than just drop our loose change, we need to drop our false beliefs that the homeless aren't human.

Drake Masters
October 12, 2016 · 👥

Black people are poor because they tip heavily, in an effort to dispel the stereotype that Black people don't tip.

Drake Masters

January 17, 2019 · 👥

I admire South Philadelphians and how they prepare for the apocalypse by parking wherever they want. It's like a whole community of elite-level Tetris players got together to say "You see that sidewalk? Fuck that sidewalk. I'm going to put my car on it. Diagonally!"

Drake Masters
June 4, 2019 · 👥

I love how hype photographers get when they post female nudes they've shot. All of sudden it's "freethenipple" this and "this is raw & uncensored" that. Which is usually followed by a rant about energy and the beauty of the nude, female form.
Nigga, shut up. You get naked in some photos for a change.

Drake Masters
May 21, 2019 ·

Gonna be honest: if the choices are those cardboard straws (that get soggy the moment liquid touches them) or plastic straws and oblivion, I'll see you in hell.

Drake Masters
September 12, 2019 · 👥

Being funny is all well and good until I'm trying to have a serious conversation and somebody's insensitive ass daughter is hehe-ing and haha-ing me over the edge when I'm not telling a joke. Where did you find the punchline in "I'm stressed out?" That's a red flag, and I don't do those. On Crip.

Drake Masters
March 31, 2020 ·

I finally understand why the hood places such great stock, and hope, into winning the lottery. It's not just because "fuck you" money grants the freedom to scoff when someone says, "guac costs extra." It's because that type of money bestows true agency. Or rather, it makes a person from an oppressed group, begrudgingly, worthy of note, and thus free to be themselves, sans the financial binds that force posturing and kowtowing. At the appropriate rung, class may supersede race. Hell, being rich even doubles as a personality trait.

Take note: Cinderella finds her happily-ever-after, not because she marries a prince, but because in doing so she elevates her class status to a level where she's finally able to liberate herself from her oppression. Lottery tickets, scratch-offs, slots, they're all just glass slippers: a chance for people to step out of their current situation and into something better.

Drake Masters
May 15, 2019 · 👥

I like how abruptly the sidewalks end in the suburbs. It's as if the designers said, "Anyone still walking after this point must be poor. Fuck 'em."

Drake Masters
April 3, 2020 · 👥

I was vegan; for maybe a week, until I ate the high horse I was on.

Drake Masters

November 22, 2018 · 👥

This Thanksgiving I'm, Lauryn Hill: showing up to your function hours behind schedule, and then only staying for 30 minutes. It sucks, but you're going to love telling the family that you saw me.

Drake Masters

January 13, 2020 · 👥

There aren't any beauty standards for men because the patriarchy would crumble under the pressure of choosing the correct foundation.

Drake Masters
June 17, 2016 · 👥

I need your help. Typically, what people would do in this situation is start a GoFundMe, but that's not going to help me through this particular disadvantage. While I am requesting donations, what I need to succeed is a currency more valuable than the U.S. dollar.

Folks, and by folks, I mean: white folks, I'm here today asking for a bit of your privilege. You may have thought I wasn't aware that you've had the juice all along. You may have even claimed to be unaware that you were in possession of it, but damn it, I know! You've been living the good life, and I want in!

White friends, contrary to popular belief, I'm not here to take everything you have. I'm just asking for the teeniest bit needed for me to reach my full potential. I'm asking you for small contributions — just a portion of your white privilege.

For less than the price of a venti, pumpkin-spice latte, you can change a life. In fact, with monthly donations of your privilege, I could truthfully select 'African American' on job applications without debate or hesitation. With weekly donations I may be able to exist in police presence without fear of being murdered. And for the truly generous contributors, who donate privilege daily, I reckon I might finally be able to get over slavery.

Folks, what I come to you seeking isn't unfettered access into the country club. Hell, I'm not even asking for a white card. I'm humbly requesting just enough white privilege to live comfortably as a Black person.

Drake Masters

November 15, 2018 ·

It must be in the lease of Chevy and Camaro owners that if it snows, you have to abandon your car in the middle of traffic.

Drake Masters
August 27, 2020 · 👥

The cop-killings don't surprise me; to be Black is to learn early, and quickly, a healthy distrust of the police. It's people and their capacity for hate, violence, and unkindness that terrify me. A darker-skinned human is murdered and under their posts, comment sections overflow with vitriol and racism. I read, and I'm awash in hatred until paranoia laps at my every thought. How can I expect these people, so proudly opposed to my existence, to not cheer for my end? How can I see, using anything but peripherals, when my assailant could be you: my neighbor, my co-worker, my friend? I'm afraid, not of uniforms, but of the uniformity of thought that opposes the notion that my life matters.

Drake Masters
July 7, 2019 · 👥

Stank ass hoes isn't a phrase that I thought I'd ever get to use, but I just installed a bidet. And now ... *Ahem* ... It's over for you stank ass hoes!

Drake Masters
November 20, 2018 ·

Sometimes I close the door to my office with a frustrated look on my face. My employees think I'm settling in for a long day of work, but in reality I just want to listen to Beyoncé in peace.

Drake Masters
July 4, 2018 · 👥

Fireworks always trigger my PTSD because I know that white people are somewhere celebrating slavery.

 Drake Masters
November 12, 2018 ·

Honestly, when the terrorists were blowing us up, the one thing that kept me going while in Iraq was the promise of free overcooked burgers at Applebee's once a year. Happy Baby-Back Ribs Day to all of my 2 for 20s!

Drake Masters
March 17, 2016 · 👥

Occasionally a woman will offer me a compliment in the form of the question: "Why are you so handsome?" I want to respond, wittily with "my parents," but I'm sure that my dad ditched me faster than he could contribute his half of my genes.

Drake Masters
August 31, 2019 · 👥

"I do, Dickhead." - A Philly couple getting married

Drake Masters
January 29, 2020 · 👥

I don't trust women that ask "What's your sign?" anymore than they should trust men that say "just the tip." In both scenarios things are going to get deeper than they should.

Drake Masters
May 8, 2018 ·

You're wasting your time with these Facebook makeover and gender-swap apps. For a modest hourly fee, I can Photoshop you into whoever you'd like to be. I fix blemishes, buck teeth, patchy beards, etc. I can take your skin from looking like Michael B. Jordan's chest in Black Panther, to his face, in 3 hours.

Drake Masters
February 16, 2020 · 👥

Texting back immediately makes you look desperate. That's why I count to five first.

Drake Masters
April 16, 2019 · 👥

Some of y'all used to step in bleach with Timbs on, and then step on your pants. Then you'd take a marker and draw flames on the front of the Timbs. I didn't forget.

Drake Masters
July 23, 2020 ·

I hate running into other bald, black dudes. Like, what the fuck are you even doing here? Shit be feeling like copyright infringement.

Drake Masters
May 2, 2019 · 👥

Fellas, you don't have to become a photographer to get women to like you. They will never like you.

Drake Masters
April 24, 2020 ·

Real shit and nigga shit are one in the same because there ain't nothing better and harder to be.

Drake Masters
September 22, 2019 · 👥

I want to be such a great photographer that after I'm dead, historians reviewing my whack shit will swear it was fire.

Writing things like: "Though his earlier works showed a burgeoning understanding of lighting and composition, Sir Masters clearly had an eye that was at least halfway open."

Drake Masters
August 18, 2019 ·

I don't smoke. I don't drink. My vice is that I struggle with gambling. I do it everyday; sometimes for hours on end. I've lost friends and family because of it, but still, it can't be helped. My game of choice is called "Are these white people going to be racist?" I always bet on black, and I always lose.

Drake Masters
October 20, 2017 ·

I don't have time for fragile masculinity. If you're a man and you want me to take your headshot, you're wearing makeup, foundation, concealer, setting powder, the works. And you better believe your sweaty face is getting blotted periodically. Motherfuckers want to spend their whole lives getting punched in the face, drinking soda, and avoiding exfoliating ... and then want me to retouch them into, Denzel. I have neither the time nor the canvas. But I've got some makeup artists that are magic. That lazy eye: makeup. Receding hairline: makeup. That dent in your face from your "crazy" ex-girlfriend: makeup. Beard patchy in spots: you guessed it, motherfucker, makeup.

Drake Masters
July 22, 2020 ·

America will find many creative ways to celebrate your life, but not until after it's killed you.

Drake Masters
February 24, 2020 · 👥

All month I've been stepping on the feet of white people wearing Air Force Ones. It ain't much, but it's honest work.

Drake Masters
March 22, 2020 ·

I called myself cheating today. Since the gym is closed I figured I'd get me a little taste of that there fast food; It's been awhile. Sweet lord, that crispy 5-piece tender meal from Popeyes, the one with fries and a biscuit, hit me like a NyQuil-soaked-Benadryl. I woke up low, slow, with sticky hands, and no concept of time. I. Am. Out. Of. It. I must have grandchildren by now, so I'm just waiting for one of my little grandbabies to come along and help me up. I hope they don't come through asking a bunch of questions though, because I am in recovery. I can hear myself now saying "You haveta hold on, suga, let me get my thoughts together."

Y'all stay inside and away from that Popeyes.

Drake Masters
August 7, 2019 · 👥

There are two types of people in this world: those with culture and class; that understand the concept of no-show socks. And those ol' goofy ass individuals of low moral thread count, that ask "wHy YoU aInT gOt No SoCkS oN?!

Drake Masters
August 25, 2020 ·

My commitment as an artist is to honesty, not popularity.

Drake Masters

October 29, 2016 ·

The best of us say that we wish to change the world. The goals are often lofty and grand: cure cancer, end world hunger, make pumpkin spice food items available year round. All noble aspirations, however, we shouldn't forget that the world is people. Forgive that poorly worded statement (and this one), better said: people are the world. What I mean is that the world isn't some abstract concept. If you want to change the world, it's as simple as being good to people. Be kind to one another.

AUTHOR'S NOTES

This page is typically devoted to acknowledgments, however,
Like That has been self-published, and thus I have no full team to
shout-out. Rather the person I want to acknowledge most is you. If
you're reading this, you've made it to the end. You may have raced
here or you may have dragged your feet, gasping for air the whole way.
In either case, you made it, and for that I'm grateful. Thank you.

The odds are that I've read this book more times than you will. And
let me tell you what: it can be a lot. In reviewing *Like That*, over and
over, I've come to realize that a continuous stream of one person's
thoughts can be taxing. In this case it's one Facebook status after
another, without the calming padding of cat videos in between. If I had
my way, you'd wake up each morning and read just one status, and the
strength of that status would carry you through the day as gently as the
aroma wafting from a pie carries a cartoon character.

I've been encouraged to include some sort of disclaimer within
these pages; something to cover my ass later down the line. If I were
a wiser man I would. I won't because I don't believe that I need to.
I understand that not everyone who reads this will be a friend with
intimate knowledge of me. I hope that this book changes that. On the
other hand, many of you reading this will have met me at one point
or another, having formed your own version, image, and opinion of
me in the process. I hope that this book changes that. *Like That* (and
Facebook before it) is my attempt to tell you who I *really* am. I often
attempt this feat using humor; it is a tool that has served me well, one
tempered with vulnerability and polished with honesty.

In closing, I apologize if I've rubbed anyone the wrong way.
What can I say? It just be *Like That* sometimes. Should you find that
these last words have done little to loosen the grip you have on your
pitchfork, I'd advise you to read the book again. And again: thank you.

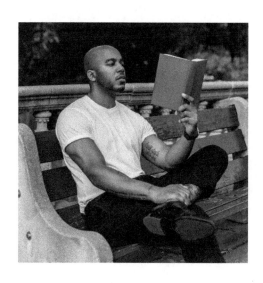

About the Author

DRAKE MASTERS is an Army veteran that quit a pursuit of law enforcement to chase after art instead. He is currently bout that life as a photographer, art director, and turtleneck connoisseur. He was born and raised in Philadelphia, PA, but currently lives in a weirdly gentrified part of Brooklyn, NY. *Like That* is his first book. Visit his website at drakemasters.com and follow @sirdrakemasters on Instagram and Twitter.

CPSIA information can be obtained
at www.ICGtesting.com
Printed in the USA
BVHW011053250920
589625BV00004B/220

9 780578 733821